Edgar Degas

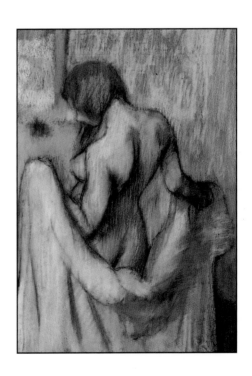

Patrick Bade

Parkstone

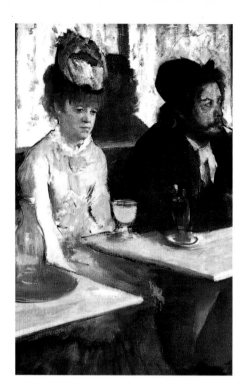

Publishing director: Jean-Paul Manzo

Publishing associate: Cornelia Sontag

Editor: Amélie Marty

Texts by: Patrick Bade

Designed by: Oliver Hickey

Photographic credits

Unless otherwise specified, copyright on the works
reproduced lies with the respective photographers.
Despite intensive research it has not always been
possible to establish copyright ownership. Where
this is the case we would appreciate notification.

ISBN 1 85995 715 3

© Copyright Parkstone New York, USA, 2000

All rights reserved.

No part of this publication may be reproduced or
adapted without the prior permission of the copy-
right holder, throughout the world.

2

DEGAS

Foreword

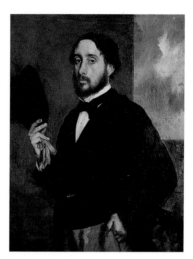

At around the time the notorious 1863 Salon des Refusés signalled the clear distinction in French painting between a revolutionary avant-garde and the conservative establishment, Edgar Degas painted a self-portrait [1] which could hardly have looked less like that of a potential revolutionary. He appears the perfect middle-class gentleman or, as the Cubist painter André Lhote put it, like "a disastrously incorruptible accountant". Wearing the funereal uniform of the nineteenth-century male bourgeois which, in the words of Baudelaire, made them look like "an immense cortège of undertakers' mutes", Degas politely doffs his top hat and guardedly returns the scrutiny of the viewer. A photograph [2] taken a few years earlier, preserved in the Bibliothèque Nationale, shows him looking very much the same, although his posture is more tense and awkward than in the painting. The Degas in the photo holds his top hat over his genital area in a gesture unconsciously reminiscent of that of the male peasant in Millet's *Angelus*. Salvador Dali's provocative explanation of the peasant's uncomfortable stance was that he was attempting to hide a burgeoning erection. Degas' sheepish and self-conscious expression also suggests an element of sexual pudeur.

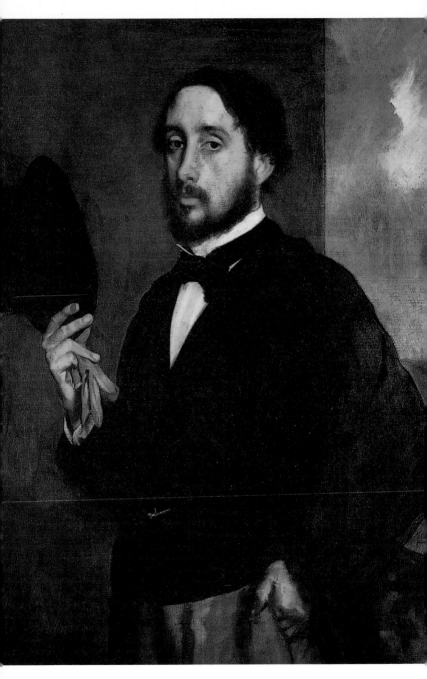

1. Self-portrait, ca. 1863
 Oil on canvas. 92.1 x 66.5 cm
 Calouste Gulbenkian Museum, Lisbon

The Degas in the photo holds his top hat over his genital area in a gesture unconsciously reminiscent of that of the male peasant in Millet's Angelus. Salvador Dali's provocative explanation of the peasant's uncomfortable stance was that he was

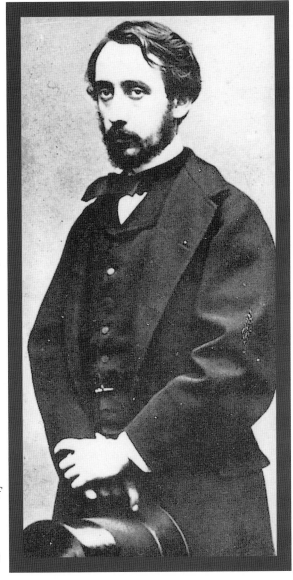

2. Edgar Degas, ca. 1855/60
Photo Bibliothèque Nationale, Paris

attempting to hide a burgeoning erection

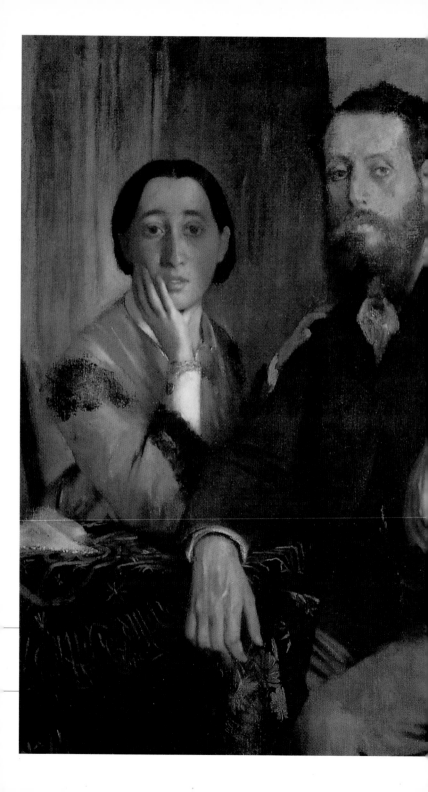

For an artist who once said that he wanted to be both "illustrious and unknown", any speculation about his sexuality would have seemed to him an unpardonable and irrelevant impertinence. Nevertheless, the peculiar nature of much of Degas' subject matter, the stance of unrelenting misogyny he adopted, and the very lack of concrete clues about his personal relationships have fuelled such speculation from the first. As early as in 1869 Manet confided to the Impressionist painter Berthe Morisot, with whom Degas was conducting a bizarre and somewhat unconvincing flirtation, "He isn't capable of loving a woman, much less of telling her that he does or of doing anything about it." In the same year Morisot wryly described in a letter to her sister how Degas "came and sat beside me, pretending to court me - but this courting was confined to a long commentary on Solomon's proverb, 'Woman is the desolation of the righteous'..."

7

3. Monsieur and Madame Edmondo Morbilli,
 ca. 1865
 Oil on canvas. 116.5 × 88.3 cm
 The Museum of Fine Arts, Boston
 Donation of Robert Treat Paine II, 1931

Rumours of a sexual or emotional involvement with another gifted woman painter, the American Mary Cassatt, can also be fairly confidently discounted, although the fact that Cassatt burnt Degas' letters to her might suggest that there was something that she wished to hide.

Degas' failure to form a serious relationship with any member of the opposite sex has been attributed to a variety of causes, such as the death of his mother when he was at the sensitive age of thirteen, an early rejection in love, and impotence resulting from a venereal infection. This last theory is based on a jocular conversation between Degas and a model towards the end of his life and need not be taken too seriously.

In 1858 Degas formed an intense and sentimental friendship with the painter Gustave Moreau. The emotional tone of Degas' letters to the older artist might suggest to modern eyes an element of homosexuality in their relationship. "I am really sending this to you to help me wait for your return more patiently, whilst hoping for a letter from you... I do hope you will not put off your return. You promised that you would spend no more than two months in Venice and Milan." But whereas Moreau's paintings exude an air of latent or even overt homosexuality, the same cannot be said of Degas'.

There are accounts of Degas chatting in mellow and contented mood with models and dancers towards the end of his life, but it seems likely that in common with many nineteenth-century middle-class men he was afraid of and found it hard to relate to women of his own class. His more outrageously misogynistic pronouncements convey a strong sense of his fear. "What frightens me more than anything else in the world is taking tea in a fashionable tea-room. You might well imagine you were in a hen-house. Why must women take all that trouble to look so ugly and be so vulgar?" or "Oh! Women can never forgive me. They hate me. They can feel that I leave them defence-less. I show them without their coquetry, as no more than brute animals cleaning themselves! ... They see me as their enemy - fortunately, for if they did like me, that would be the end of me!"

Degas' portraits of middle-class women have faces, unlike his dancers, prostitutes, laundresses, milliners and bathers who are usually stereotyped or quite literally faceless. On the other hand, these middle-class women may seem intelligent, rational and sensitive but are nevertheless a grim lot, without warmth or sensuality. Many of Degas' female relatives seem to be overwhelmed by frigid and loveless melancholy.

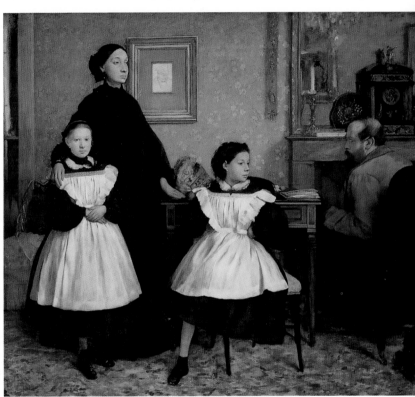

4. The Bellelli Family, 1858/67
 Oil on canvas. 200 x 250 cm Musée d'Orsay, Paris

His nieces Giovanna and Giulia Bellelli [4] turn from one another without the slightest trace of sisterly intimacy or affection. Grimmest of all is the portrait of his aunt, the Duchess of Montejasi Cicerale, and her two daughters in which the implacable old woman seems to be separated from her offspring by an unbridgeable physical and psychological gulf.

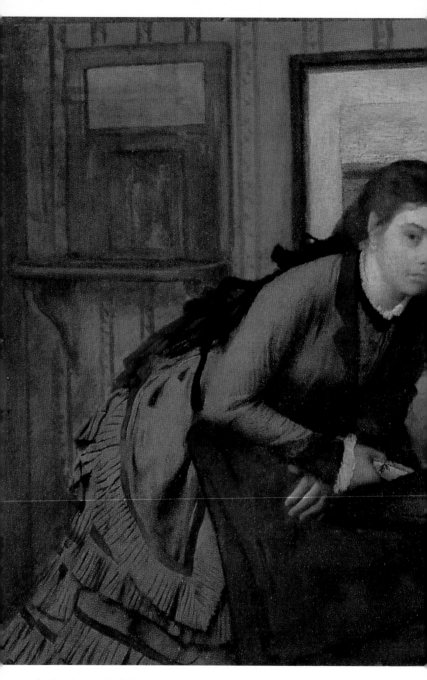

5. Pouting, ca. 1869/71
 Oil on canvas. 32.4 × 46.4 cm. The Metropolitan Museum of Art, New York
 Bequest of Mrs H. O. Havemeyer, Collection H. O. Havemeyer

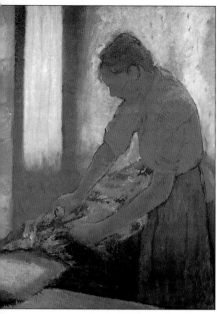

6. The Ironer, ca. 1880
 Oil on canvas. 81 x 66 cm
 Walker Art Gallery, Liverpool

7. The Rape, ca. 1868/69
 Oil on canvas. 81 x 116 cm.
 Philadelphia Museum of Art,
 Philadelphia
 Collection Henry P. Mc Ilenny in
 memory of Frances P. McIlhenny

The theme of tension and hostility between the sexes
underlies many of Degas' most ambitious works of the
1860s, both in genre-like depictions of modern life such as
Pouting [5] and *Interior* (formerly known as *The Rape* [7]
and probably inspired by Zola's novel *Thérèse Raquin*) and
in elaborate historical scenes such as *Young Spartan Girls
Challenging the Boys* [11] and *Scene of War in the Middle
Ages* [9]. This last - the most lurid and sensational picture
Degas ever painted - shows horsemen shooting arrows at a
group of nude women. The women's bodies show no
wounds or blood but fall in poses suggestive more of erotic
frenzy than of the agony of death.

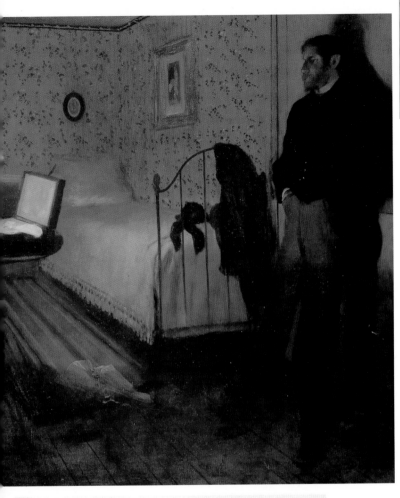

8. Half-nude Woman, Lying on her Back, 1865
Pencil. 22.8 × 35.6 cm. Musée d'Orsay, Paris

13

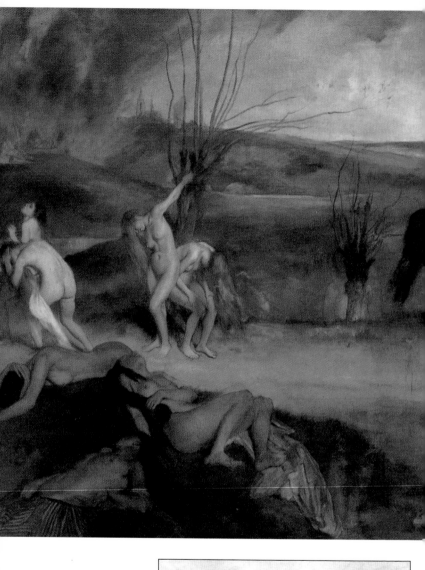

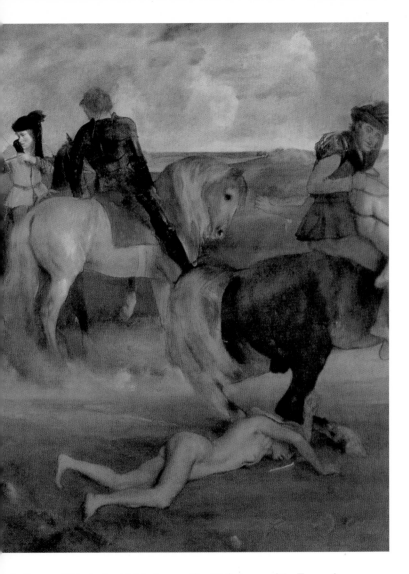

9. Scene of War in the Middle Ages or The Misfortunes of the Town of
 Orléans, 1865
 Oil on paper mounted on canvas. 81 × 147 cm Musée d'Orsay, Paris

Opposite page:
10. Young Spartan Girl, ca. 1860
 Pencil on paper. 22.9 × 36 cm Musée d'Orsay, Paris

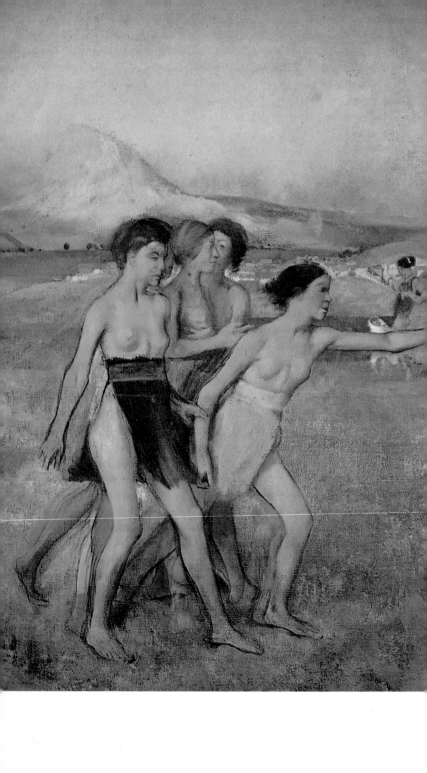

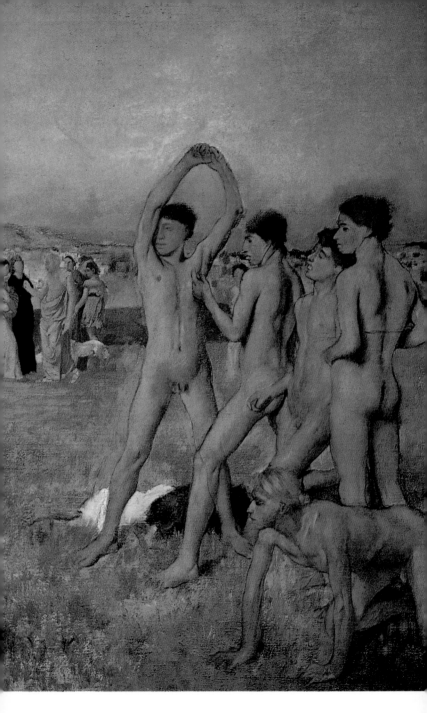

11. Young Spartans, ca. 1860-62
Oil on canvas. 109 × 155 cm National Gallery, London

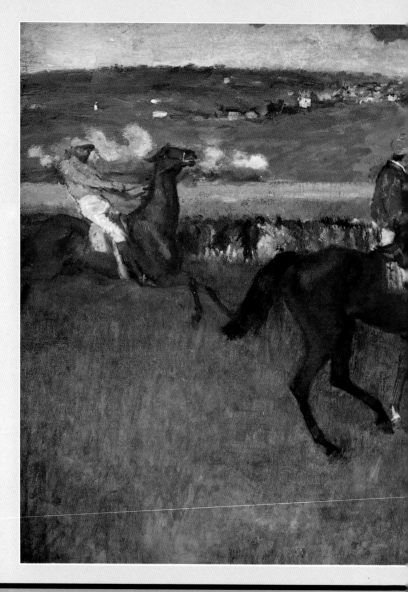

12. At the Races, Gentlemen Jockeys, ca. 1876/77
 Oil on canvas. 66 × 81 cm
 Musée d'Orsay, Paris

From the time that Degas reached maturity as an artist in the 1870s, most of his depictions of women - apart from a few middle-class portraits - include more than a suggestion that the women are prostitutes. Prostitution in nineteenth-century Paris took a wide variety of forms, from the bedraggled street-walker desperate for a meal to the *Grande Horizontale* able to charge a fortune for her favours. Virtually any woman who had to go out to work and earn a living was regarded as liable also to have to sell her body. So it was that Degas' depictions of singers, dancers, circus performers and even milliners and laundresses could have disreputable connotations for his contemporaries that might not always be apparent today.

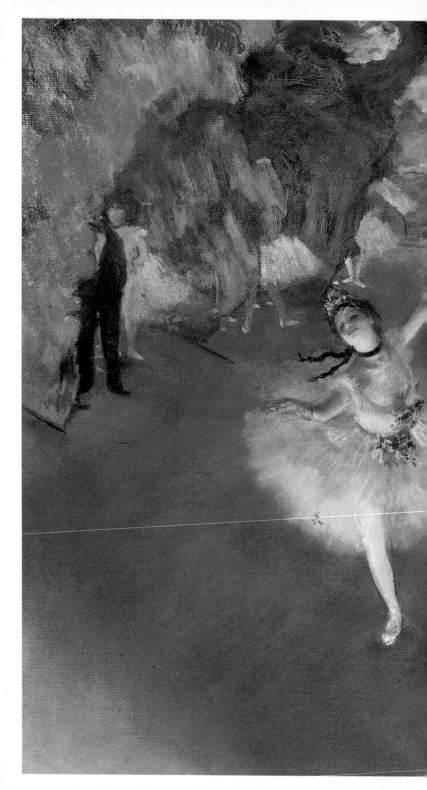

It was during the Second Empire (from 1852 to 1871) that Paris consolidated its reputation as the pleasure capital of Europe. That "love for sale" was one of the chief attractions of Paris for foreign visitors is made abundantly clear by the operetta *La Vie Parisienne* composed by Jacques Offenbach for the 1867 Paris World Exhibition. The libretto, written by Degas' close friend Ludovic Halévy and his collaborator Henri Meilhac, shamelessly celebrates Paris' reputation as "the modern Babylon" and a great focus for venal love. Amongst the characters are a *Grande Horizontale* with the outrageously punning name of Métella (roughly translatable as "put it in"), a pretty glovemaker called Gabrielle who might have stepped from one of Degas' pastels of milliners, a Brazilian millionaire who wants to lose his fortune to Parisian "hussies", a Swedish Baroness who longs to hear the singer Thérésa (about whom we shall hear more later) and her husband who wants to experience and enjoy everything at once "jusque-là!".

13. Ballet (The Star), 1879-81
 Pastel over monotype. 58 × 42 cm
 Musée d'Orsay, Paris

Prostitution was a major theme of French writers and artists throughout the second half of the nineteenth century. Literary interest in prostitution peaked in the years around 1880. Edmond de Goncourt published *La Fille Elisa* in 1877, and Emile Zola *Nana* in 1879-80. Guy de Maupassant made his reputation with *Boule de Suif* in 1880 and followed it up the next year with the endearing *La Maison Tellier*.

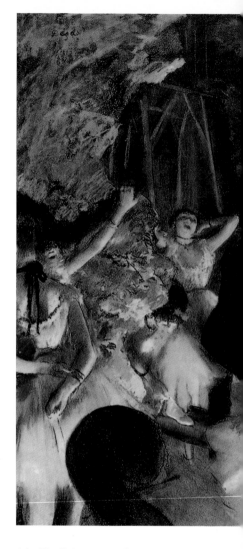

14. The Rehearsal on Stage, 1874 (?)
Pastel over brush and ink on paper.
55.3 x 72.3 cm
The Metropolitan Museum of Art,
New York, H. O. Havemeyer Collection

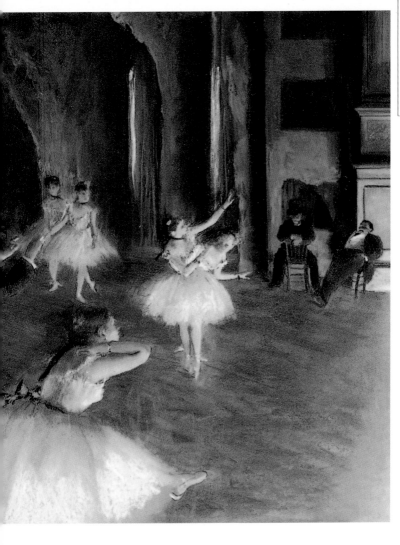

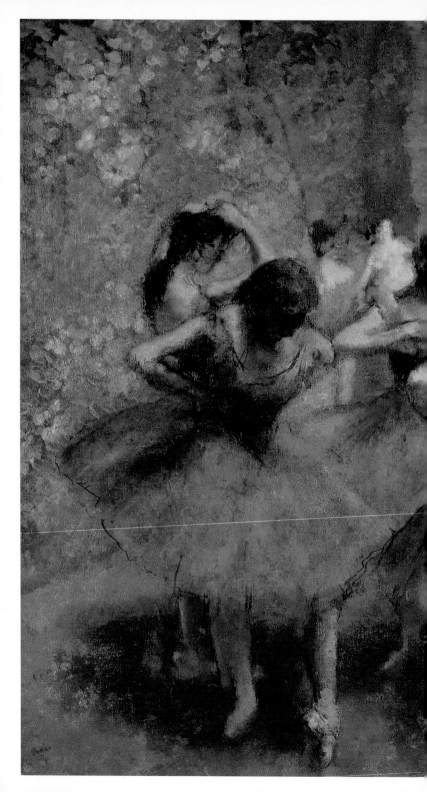

Degas' references to the Parisian traffic in female flesh were often scrupulously discreet - a glimpse of a gentleman's black trousers amongst the coulisses of the opera, or of the gaudy plumage of a courtesan's hat at the race-course as her carriage passes from view. Sometimes it is no more than a pervasively suggestive atmosphere that would nonetheless have been quite perceptible to men of Degas' class and tastes.

15. Blue Dancers, ca. 1893
 Oil on canvas. 85 × 75.5 cm
 Musée d'Orsay, Paris

16. Mademoiselle Lala at the Cirque Fernando, 1879
 Oil on canvas. 117 x 77.5 cm
 National Gallery. London

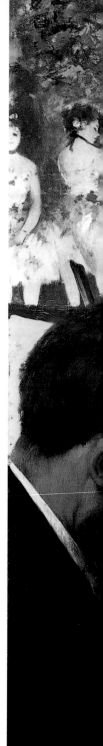

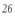

17. Orchestral musicians
 Oil on canvas. 62 x 49 cm
 Städtisches Kunstinstitut, Frankfurt

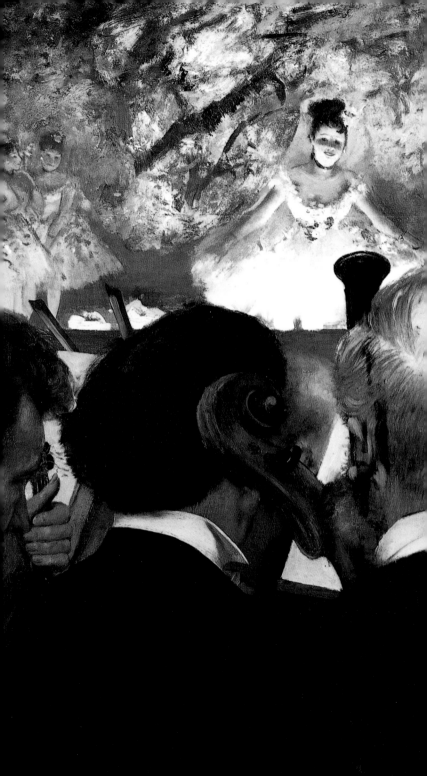

This murky world of commerce in females indulged in by predatory top-hatted males is illuminated in a fascinating if somewhat lurid way by two anonymous Parisian publications of the 1880s when Degas was at the height of his powers. *Ces Demoiselles de l'Opéra* published in 1887 and attributed to *Un Vieil Abonné* ("a long-time season-ticket-holder") offers a survey of all the female dancers currently active at the new Paris Opera and looks back nostalgically to the 1860s when Degas too began to interest himself in ballet at the old house in the *Rue Lepeletier*.

28

18. Dancers in the Wings, 1878-80
 Pastel and tempera on paper. 69.2 × 50.2 cm
 The Norton Simon Museum of Art, Pasadena

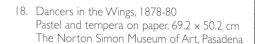

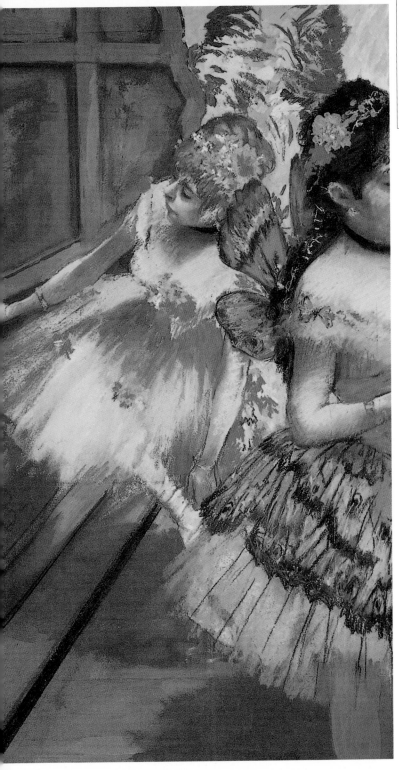

19. At the Milliner's, ca. 1882-86
Pastell on paper. 100 × 111 cm Art Institute, Chicago

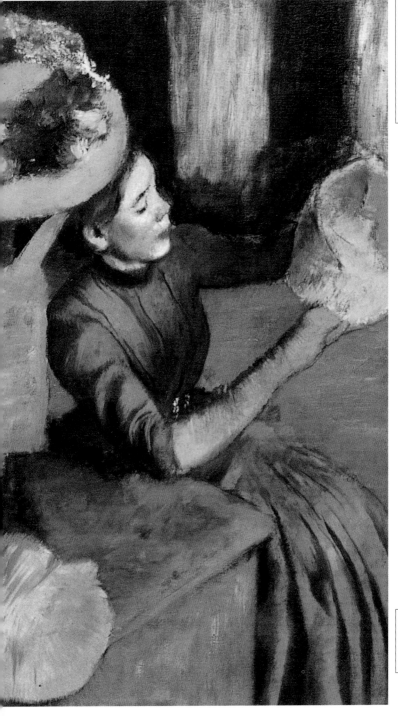

20. Portrait of Mademoiselle E(ugénie) F(iocre) on the occasion of the Ballet
 "The Source", 1867/68
 Oil on canvas. 103 x 145 cm Brooklyn Museum, New York

The tone of the book is gossipy and mildly lecherous. *The
Vieil Abonné* seems more interested in the physical attrac-
tions of the dancers and in the racy details of their private
lives than he is in the finer points of their dancing tech-
niques. Mlle Eugénie Fiocre, the only female dancer
described in the book and identifiably painted by Degas [20],
is said to have "a nose for which an umbrella would be useful"
- Degas' study of her shows that she had a rather retroussé
and exceptionally pretty nose - "but what a figure! One
should go down on one's knees in front of it - and behind!"

Ces Demoiselles de l'Opéra vividly conveys the flavour of the flirtatious conversations that Degas enjoyed with his young dancer models. Daniel Halévy, the son of Degas' old friend Ludovic, noted that when Degas was with dancers he "finds them all charming, makes excuses for anything they do, and laughs at everything they say." *The Vieil Abonné* recorded the foibles, the bons mots and the bêtises of the dancers with the same affectionate indulgence. So we hear, for example, that the only distinguishing characteristic of Léontine Beaugrand was an inordinate love of chocolates, and how la petite Paillier was outraged when complimented by an admirer as looking like a Boucher, thinking that he was comparing her with a butcher.

The Pretty Women of Paris was published in English in 1883, and describes itself on the title page as a "Complete Directory and Guide to Pleasure for Visitors to the City of Gaiety". The information offered about Parisian women is so comprehensive and so detailed that it cannot possibly have been compiled by one man. The tone throughout, though, is consistent - scurrilous, and often misogynistic. It gives a reader the impression of coming face to face with all the anonymous and faceless women who people Degas' oeuvre, from star dancers to milliners and laundresses.

On the first page we encounter Ellen Andrée, who was the model for Degas' *Absinthe* [21]. "She is a very pretty fair woman, whose artistic talents are small, although her body is in splendid proportion for such a tiny creature. Her principal lovers number among the artists of the capital city, for whom she has often posed as model. She has been photographed in many attitudes, always without any clothing, and these studies from life are to be bought all over Paris for a small sum. She is very straightforward and kind-hearted, but cannot write or read with facility, her education having been greatly neglected. She is about twenty-four years old."

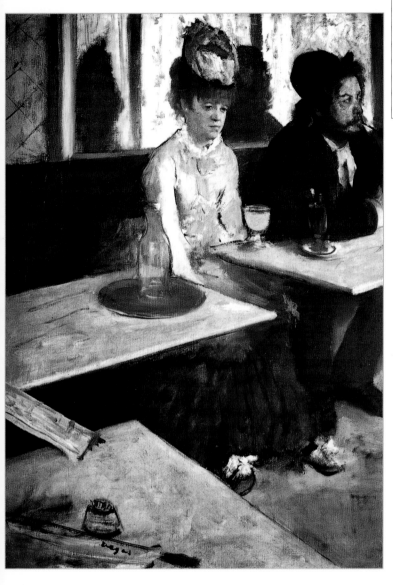

21. In a Café, also called The Absinthe, 1875/76
 Oil on canvas. 92 × 68 cm
 Musée d'Orsay, Paris

It seems that the authors underestimated her age, her intelligence and her dramatic talents. She is unlikely to have been sixteen when she posed as the weary prostitute in Degas' *Absinthe* in 1876, she clearly had the wit to hold her own among the riproaring company of Degas and his friends at the Café de la Nouvelle Athènes in the 1870s, and she went on to enjoy a long and distinguished career in the theatre.

On later pages of this "Directory and Guide" we meet Thérèse Bréval, who "was a ballet-girl for a time, but soon grew tired of kicking up her legs for such small wages"; Marie Folliot, "formerly an assistant in a milliner's shop, but her beauty singled her out for the advances of the seducer.."; Blanche de Labarre, employed in the corset department of a large store where "the habit of continually taking off and trying on so many pairs of stays seems to have had an effect on her morals and made her ever afterward only too ready to unlace her own..."; Amélie Latour, "a simple laundress" who "used to carry washing home to the customers, who, in return for the clean linen she brought, would often rumple her chemise and petticoats"; the circus performer Oceana, "a female acrobat turning double somersaults without a stitch on is a splendid sight for a tired old rake..."; Countess Letischeff who "began to frequent all the race-meetings round Paris"; and Glady and Marie Magnier who both began life like Henri Murger's Mimi by making artificial flowers.

Degas' most direct and explicit depictions of prostitution date from the late 1870s and constitute a series of monotype prints of brothels [22-31] which are exceptional in his oeuvre in a number of ways. By the time Degas came to produce these images, the Parisian brothel was already in decline and represented a somewhat old-fashioned way for the middle-class gentleman to take his pleasure. *The Pretty Women of Paris* lists ninety-nine brothels within central Paris and a further seven in the suburbs. The one hundred and eighty-three women described individually in the book all worked independently of brothels, however. Fanny Robert, for example, started her career in a brothel in Marseilles but was "rescued and brought to Paris by a rich lecher".

22. In the Salon, ca. 1876/77

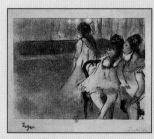

23. Boarders in Night-dress, ca. 1876/77

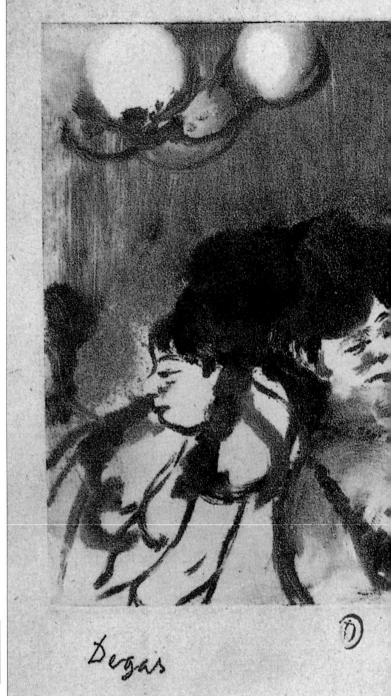

Degas

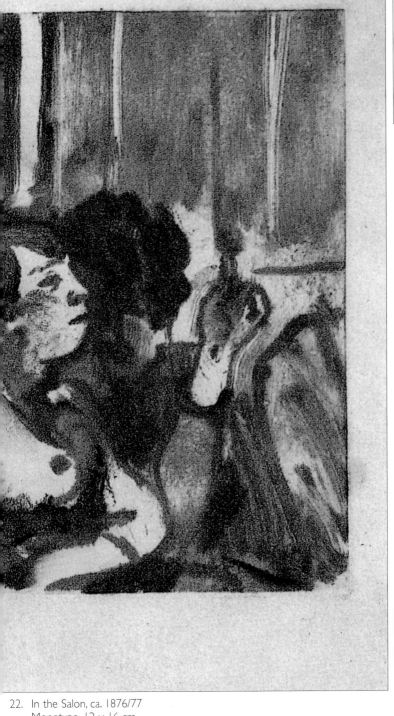

22. In the Salon, ca. 1876/77
Monotype. 12 × 16 cm
Bibliothèque d'Art et d'Archéologie, Paris (Fondation Jacques Doucet)

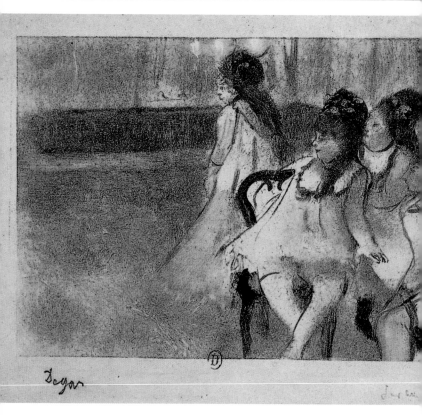

23. Boarders in Night-dress, ca. 1876/77
 Monotype. 11.9 × 16.2 cm
 Bibliothèque d'Art et d'Archéologie, Paris (Fondation Jacques Doucet)

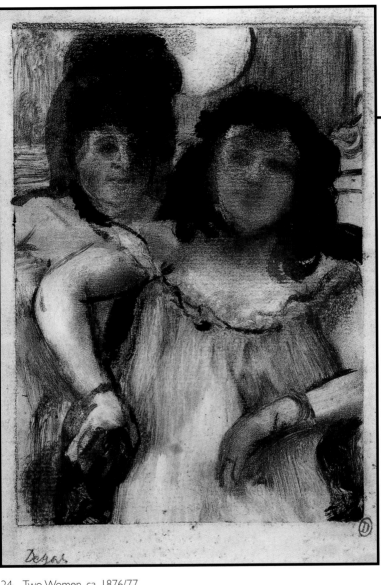

24. Two Women, ca. 1876/77
 Monotype. 16.3 × 11.9 cm
 Bibliothèque d'Art et d'Archéologie, Paris (Fondation Jacques Doucet)

"The women loll around on the plushly upholstered furniture in relaxed open-legged postures, comfortable in their nudity or semi-nudity and in their proximity to one another."

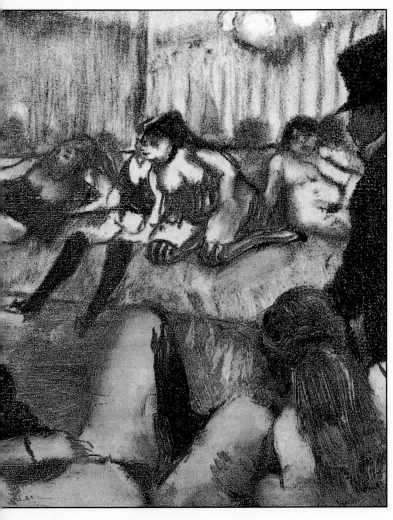

25. In the Salon, ca. 1876/77
 Monotype. 15.9 × 21.6 cm
 Musée Picasso, Paris

The life of a registered prostitute in a licensed brothel must have been a tough one. Apart from the drudgery of the work, the women were subject to regular medical inspections and other petty and humiliating restrictions. Yet - as described in the fiction of the period and "realist" cabaret songs - life in a brothel was not without its compensations and attractions. The song *En Maison*, sung by Damia, dubbed *la Tragédienne de la chanson*, tells of a young girl who is rescued from a brothel by marriage to a middleclass man, but who comes to miss the freedoms and the *petites habitudes* of her life in the whorehouse.

44

26. Repose, ca. 1876/77
Monotype. 15.9 x 21 cm
Musée Picasso, Paris

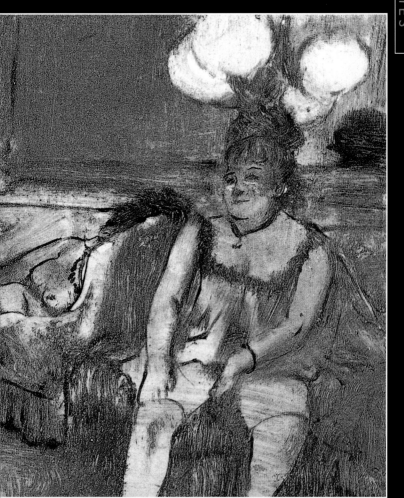

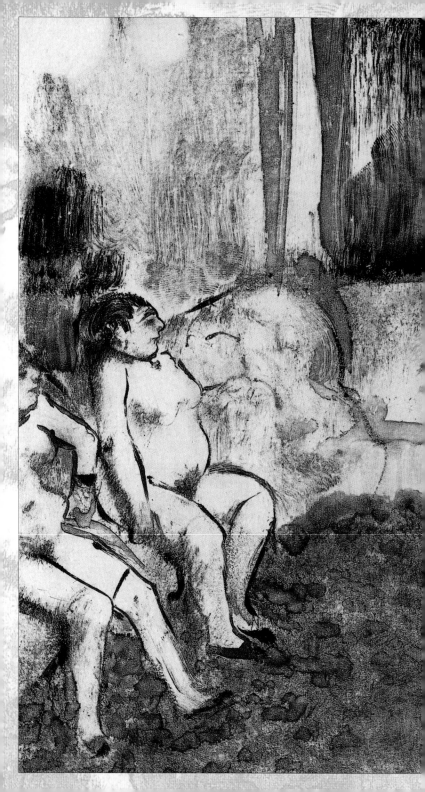

Degas' prostitutes do not look oppressed or unhappy. These brothel scenes are the most exuberant images he produced and have an earthy humour and a *joie-de-vivre* not found elsewhere in his work. The women loll around on the plushly upholstered furniture in relaxed open-legged postures, comfortable in their nudity or semi-nudity and in their proximity to one another. By contrast, it is the black-clad women of Degas' portraits with their rigid body language who seem repressed and oppressed.

27. The Customer, ca. 1876/77
 Monotype. 22 × 16 cm
 Musée Picasso Paris

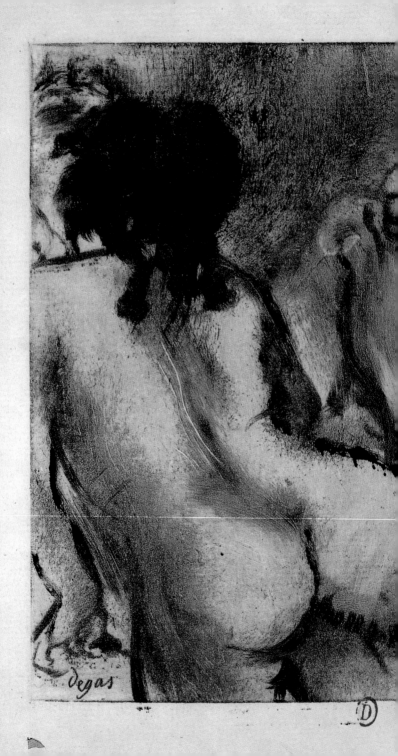

degas

28. The Procuress, ca. 1876/77
 Monotype. 16.5 × 11.8 cm
 Bibliothèque d'Art et d'Archéologie,
 Paris (Fondation Jacques Doucet)

The good-humoured and warm-hearted behaviour of the women in the brothel prints anticipates the mood of Guy de Maupassant's famous short story *The House of Madame Tellier*, published in 1881, in which the prostitutes lavish their warmth and affection on a young girl taking her first communion. "All the women were eager to fondle her, seeking an outlet for those affectionate demonstrations, that habit of caressing induced by their profession, which had impelled them to kiss the ducks in the railway carriage."

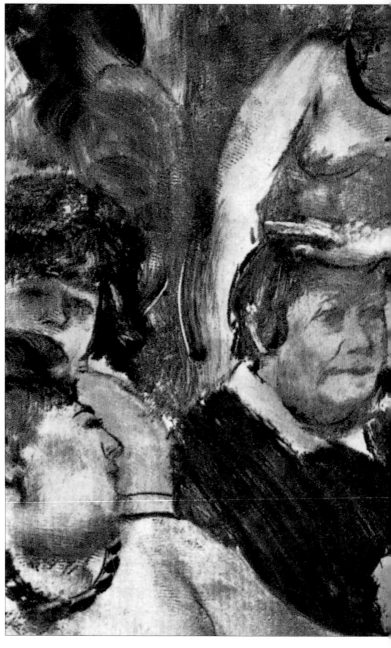

29. Madame's Name-Day, 1876/77
Monotype. 11.5 × 15.9 cm

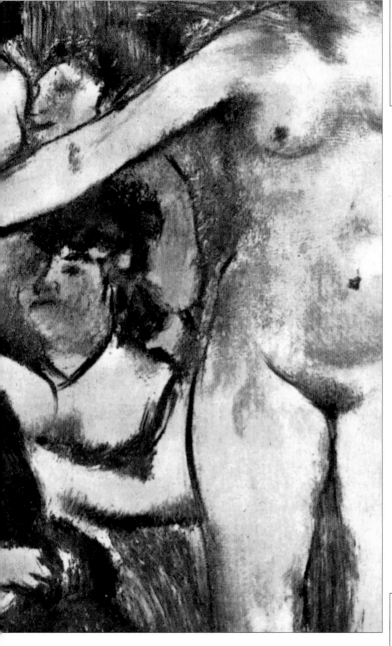

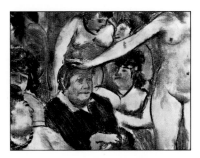

Among the most delightful of the prints is *Madame's Name-Day* [29] which Degas later reworked in pastel. A portly madame, dressed in respectable black and looking horribly like a caricature of the Widow of Windsor (Queen Victoria), is surrounded by girls wearing only shoes and lavender stockings who offer her bouquets of flowers. Once again we are reminded of *The House of Madame Tellier*, in which the women of the house "threw their arms round Madame Tellier and hugged her, as if she were an indulgent mother overflowing with kindness and good will."

Following spread:
30. Scene in a Brothel, ca. 1876/77
 Monotype. 16.1 x 21.5 cm
 Bibliothèque d'Art et d'Archéolo-
 gie, Paris (Fondation Jacques
 Doucet)

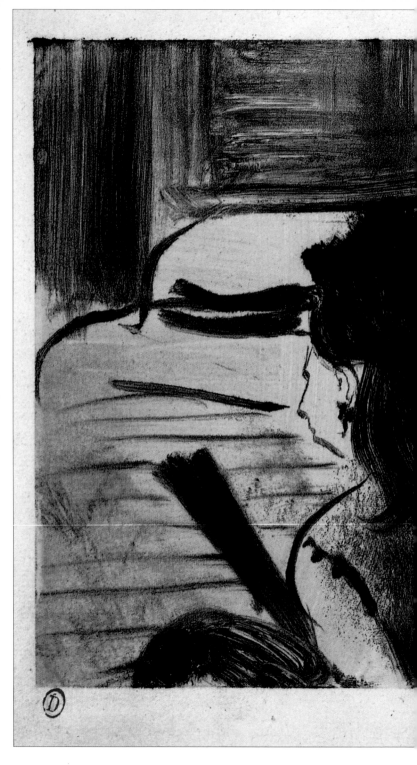

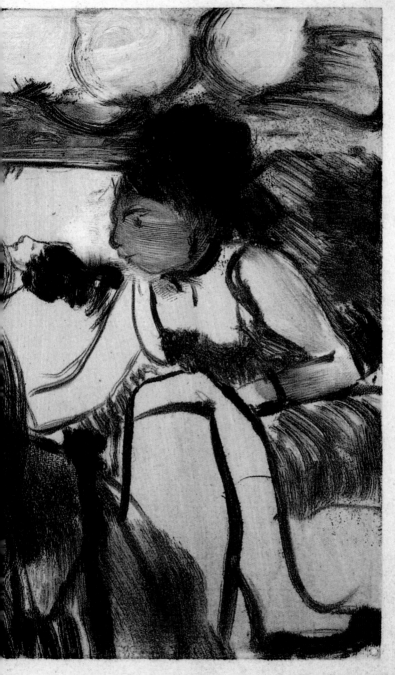

Degas

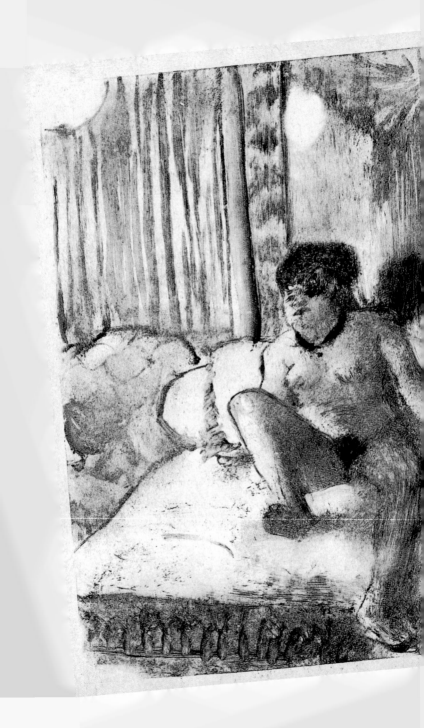

The stocky women depicted in these monotype prints belong to a different physical type - almost, it would seem, to a different species - from the statuesque laundresses, the more slender dancers and the tightly-corseted middle-class ladies. This sturdily thick-set type was clearly much in demand by nineteenth-century clients of prostitutes. The adjective "stout" is used with great approbation throughout *The Pretty Women of Paris*.

31. Repose on the Bed, ca. 1876/77
 Monotype. 16.1 x 12 cm
 Collection Jean-Claude Roumand,
 Paris

Many of the women are described in terms strongly reminiscent of Degas' images. Marie Kolb is "a pleasant, little ball of fat", and Blanche Querette "a most lascivious dumpling, and every bit of her fleshy frame is deserving of worship". Berthe Laetitia is "short, and her well-rounded form is developed to the utmost, all her bones being covered with firm layers of elastic flesh, and her breasts and buttocks being sights to behold." Marie Martin is "a fine, dark Spanish-looking matronly woman, with semi-globes like a Dutch sailor's wench, and a pair of hips and a monumental backside that would make a Turk go off like a bottle of ginger-beer on a hot day." Berthe Mallet is "the very woman for a man who likes to wallow in a mass of white flesh..."

32. "The Marquis Cavalcanti was the one who turned round most often", 1880
Illustration to Ludovic Halévy's Cardinal stories
Monotype. 21.5 × 16 cm

Following spread:
33. "Pauline and Virginie talking to admirers", 1880
Illustration to Ludovic Halévy's Cardinal stories
Monotype. 21.5 × 16.5 cm
Fogg Art Museum, Cambridge, Massachusetts
Harvard Art Museum, Bequest of Meta and Paul Sachs

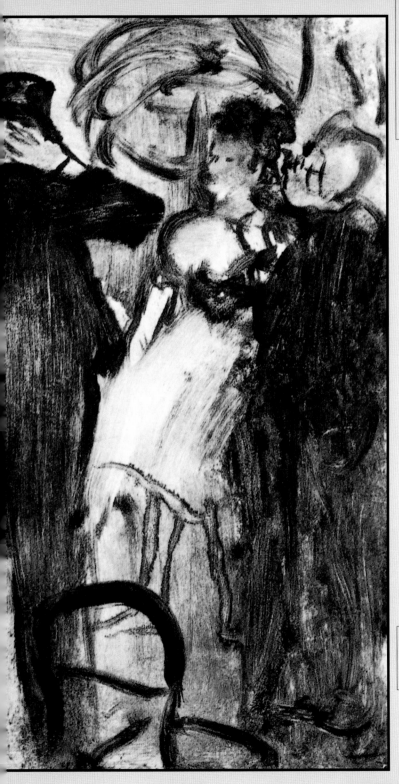

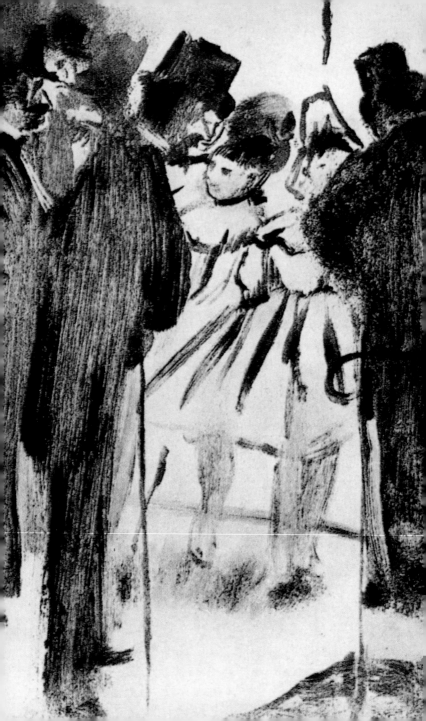

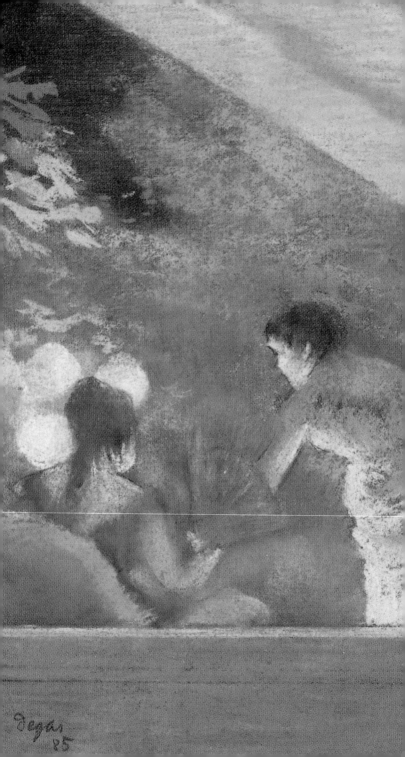

degas
85

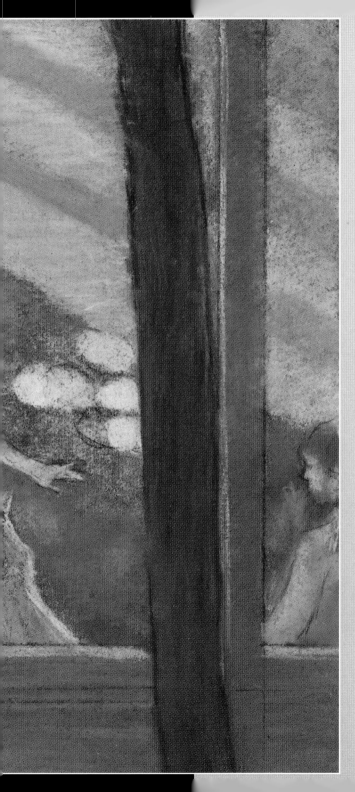

Several of these prints, as well as many of the later pastel and oil *Toilettes* [39-49], show Degas' fascination with large and fleshy buttocks. In this too, he shared tastes with the compilers of *The Pretty Women of Paris*, who wax enthusiastic about the "enormous, fascinating buttocks" of Ernestine Desclauzes. As for Zulmar Bouffar, the brilliant operetta star who created the role of the pretty glove-maker Gabrielle in Offenbach's *La Vie Parisienne*, they tell us that "Her best parts are her posterior beauties: even the Hottentot Venus cannot boast such a well-formed pair of sculptured marble buttocks."

Preceeding spread:
34. In the "Café des Ambassadeurs", 1885.Pastel.
 26.5 x 29.4 cm. Musée d'Orsay, Paris

The residents of Degas' brothels differ from the bland, idealised nudes exhibited at the Paris Salons not only in their physical proportions and facial types but also in their frank display of abundant pubic hair. Nowhere is the sexual schizophrenia of the nineteenth century more apparent than in the contrast between the hairless perfection of nineteenth-century academic nudes and the relish with which the pubic hair of the women in *The Pretty Women of Paris* is itemised in the most minute and precise detail. So we learn that Bacri "can boast the best bush that ever grew below a moll's navel"; that the mons Veneris of Laure Decroze "is protected by a splendid, soft, curly chestnut bush"; "The neat body and flowing locks of golden hue" of Emilie Kessler "will be sure to excite desire in the male, especially when he makes the discovery that her tangled bush is as black as night, affording a rare and pleasing contrast."

Marie Martin is "a fine, dark Spanish-looking matronly woman, with semi-globes like a Dutch sailor's wench, and a pair of hips and a monumental backside that would make a Turk go off like a bottle of ginger-beer on a hot day."

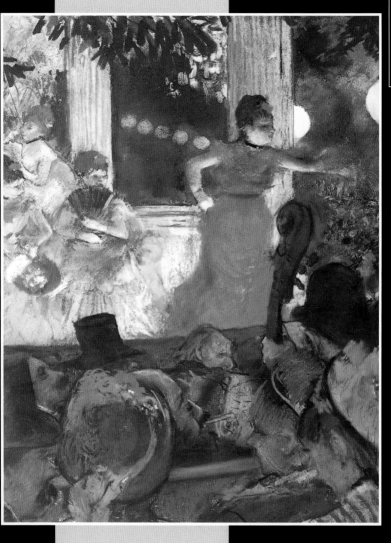

35. Concert in the "Café des
 Ambassadeurs", ca. 1876
 Monotype. 37 x 27 cm
 Musée des Beaux-Arts,
 Lyon

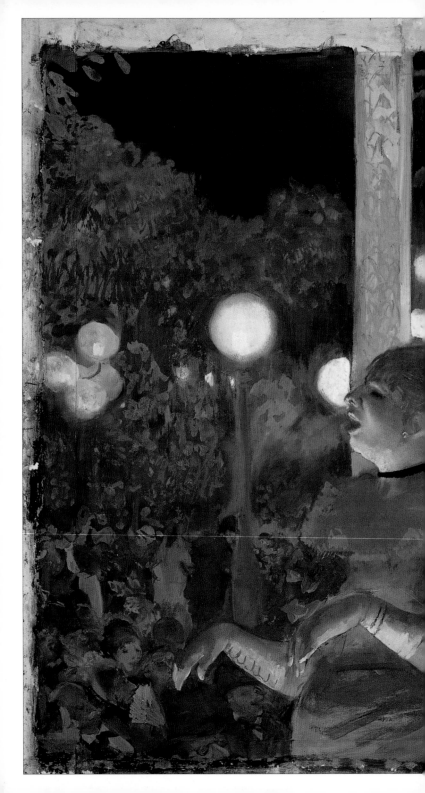

36. The Song of the Dog, ca. 1876/77
 Monotype of gouache and pastel.
 57.5 × 45.4 cm. Private Collection

69

37. Singer with a Glove, ca 1878
Pastel on canvas. 52.8 × 41 cm
Fogg Art Museum, Cambridge,
Massachusetts
Bequest from the Collection
of Maurice Weinheim

The brothel prints display a caricatural and gently satirical element that is virtually unique in Degas' work. This is most apparent in Degas' mockery of the bashful bowler- or top-hatted clients, dressed as always in the black uniform of the "undertaker's mutes". In *The Serious Customer*, for example, a curvaceous prostitute (whose body is modelled almost entirely in Degas' fingerprints) reaches out to encourage the timid bowler-hatted client.

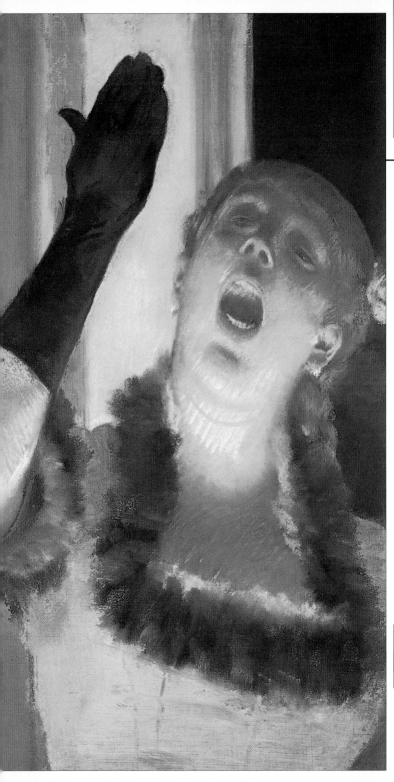

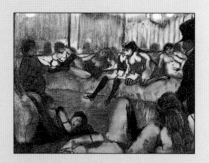

In several of these images the notorious acerbity and terseness of Degas' conversational wit finds a nice visual equivalent in the oblique and abbreviated way that he refers to the presence or approach of the male client. *In the Salon* [25] shows a black-suited client with a top hat and stiffly-starched shirt collar entering a room filled with prostitutes disporting themselves in the most carelessly abandoned poses. In *Repose* [26] and *The Customer* [27], we see no more than the client's nose and a narrow strip of the black fabric of his trousers.

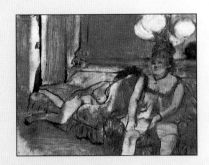

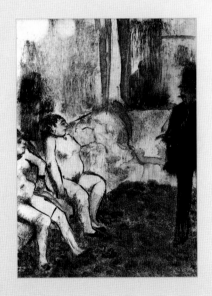

38. Two Women (Scene in a Brothel), ca. 1879-80 or 1876/77
Monotype, 24.8 × 28.3 cm.
Museum of Fine Arts, Boston
Katherine Bullard Fund

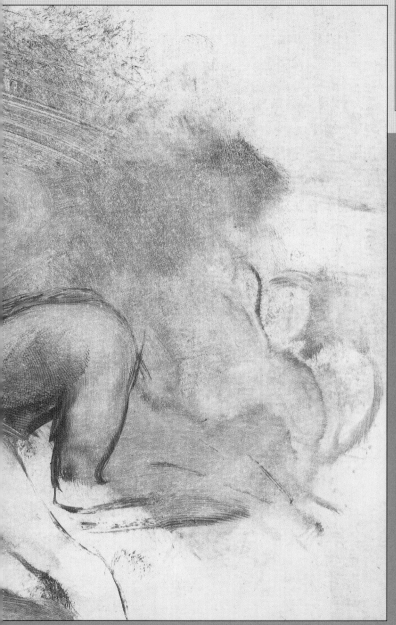

One of the most voluptuous of the brothel monotype prints, *Two Women (Scene in a Brothel)* [38], combines two potent male fantasies: lesbianism and interracial sex. If we are to believe the authors of *The Pretty Women of Paris*, lesbianism, or "tribadism" as they so quaintly put it, was common practice amongst Parisian prostitutes, although its extent may well have become exaggerated in their overheated imaginations.

These lesbian encounters are described in the book with that curious mixture of moral disapproval and salivating prurience that still characterises attitudes to sex in much of the British popular press. So we read of the "disgusting caresses" common to French prostitutes and the "Sapphic ties of which Parisian unfortunates are generally so fond", and of Janvier, "an insatiable devotee of lesbian love" who "pursues her prey in the corridors of the Opera like a man", of Nina Melcy, mistress of a British Member of Parliament who "adores her own sex, but only when there is an important debate in the House", and of Juliette Grandville who is "often Sappho by day and Messalina by night, rushing eagerly to the arms of her masculine adorer with

the glorious traces of some girlish vic-
tim's excitement on her feverish ruby
lips."

To see lesbian acitivity was clearly excit-
ing to many men in nineteenth-century
Paris. We are told of Thérèse Bréval that
"A favourite after-supper diversion is the
spectacle of Thérèse making love to one
of her own sex." Still closer to Degas'
print is the description of the love-mak-
ing of Laure Heymann with the black
Countess Mimi Pegère: "It is a glorious
sight to see the fair Laure locked in the
serpentine embrace of the lecherous little
Sappho, who is as black as coal, being a
native of Haiti."

In its listing of the licensed brothels of
Paris, *The Pretty Women of Paris* describes
the brothel at 12 Rue de Charbanais as
"The finest bagnio in the world. Each
room is decorated in a different style,
regardless of expense... A negress is kept
on the establishment. This is a favourite
resort of the upper ten, and many ladies,
both in society and out of it, come here
alone, or with their lovers, for lesbian
diversions."

The monotype prints of brothels are among the most private and personal of Degas' works. It was rare for him to treat the theme of prostitution as directly and openly in his larger-scale and more public works. An exception, though, was *Women on a Café Terrace, Evening*, which Degas showed at the Third Impressionist Exhibition in 1877. Like *Madame's Name-Day* [29] it is executed in pastel on top of a monotype print, but on a considerably larger scale. It shows gaudily-plumed and fashionably-dressed prostitutes going about their business of attracting passers-by on a busy gas-lit boulevard. These women could easily be the sisters de Lamothe described in *The Pretty Women of Paris* as looking "extremely attractive" by gaslight and as "assiduous frequenters of the fashionable cafés of the Boulevard each night".

At the approach of winter they "pack up their bidets for Nice, where they astound all beholders with their ultra-fashionable clothing and commanding appearance." The top-hatted, dark-suited gentleman seen dis-appearing hurriedly to the right is evidently a potential customer. The woman to the left, rising from her seat but shown bisected by a column, may be responding to his furtive invitation.

Most striking of all is the prostitute in the centre, who raises her thumb to her teeth in an insolent and provocative gesture that has been much commented upon and variously interpreted. We know from Guy de Maupassant's short story *Playing With Fire* - about a respectable woman who catches the attention of a passing male from her balcony, with disastrous consequences - that an almost imperceptible gesture in the street was all that was needed to strike a sexual bargain.

From the brothel to the opera
house was not such a great leap,
if we are to believe the authors of
The Pretty Women of Paris. "All
the women at the National Acad-
emy of Music are venal whores,
and to outline their biographies
would necessitate a volume devot-
ed to that building alone, which
is nothing more than a gigantic
bawdy-house. From the appren-
tice ballet-girl, just out of her
teens, down to the high-salaried
principal songstress, all are to be
had for the asking - the payment
varying from a supper and a new
pair of boots, to hundreds of
pounds."

With a view softened somewhat by nostalgia, the Vieil Abonné also evokes the sexually-charged atmosphere of the old opera house in the Rue Lepeletier. "Then, pushing through the lobby door which led onto the stairs of the wings, spreading up these staircases - trotting, chirping, humming, laughing, opening love-letters, breathing in bouquets of flowers, nibbling sweets or apples - [went] the entire flight of these charming creatures, the loves and the pleasure of Paris at that time, who were the light, the animation, the life, the joy of the poor old building..."

In the last thirty years of the nineteenth century when Degas painted and drew his images of dancers, ballet was going through an artistic trough and was far from the respected and elevated art form it has been ever since the time of Diaghilev.

After visiting Degas in his studio in 1874, the writer Edmond de Goncourt noted in his diary that Degas was able to demonstrate various balletic positions. The sight of the conservative and already rather middle-aged Degas performing pirouettes in his studio must have been a strange one. However, it seems likely that it was not so much the techniques of dancing that fascinated Degas as the louche atmosphere backstage. Degas rarely depicted an actual performance, and when he did, the illusion is always compromised by some intrusive element of banal reality, such as the top of a musical instrument [14, 16] that rises up from the orchestra pit or a glimpse of the dark trousers of the star dancer's "protector" standing in the wings. Although the atmosphere of the backstage traffic in flesh is all-pervasive, it is once again only in the more private medium of the monotype print that Degas gives it more explicit expression.

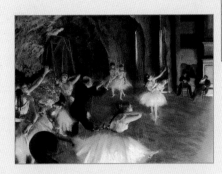

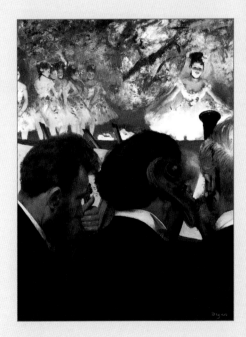

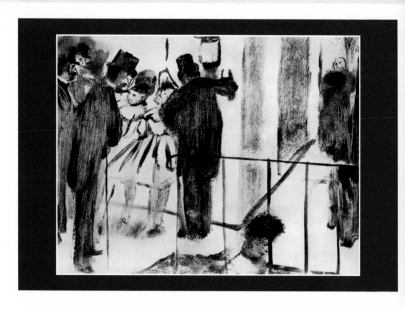

33. "Pauline and Virginie talking to admirers", 1880
 Illustration to Ludovic Halévy's Cardinal stories
 Monotype. 21.5 × 16.5 cm
 Fogg Art Museum, Cambridge, Massachusetts
 Harvard Art Museum, Bequest of Meta and Paul Sachs

In the late 1870s, round about the time that Degas produced his brothel prints, he used the same medium for a series of sharp and witty illustrations to the stories written by Ludovic Halévy about the Cardinal family [33]: two young dancers at the Opera, Pauline and Virginie, and their wily parents M. and Mme Cardinal, who nurture their daughters' dancing and amorous careers. Halévy, who today is chiefly remembered as co-librettist with Henri Meilhac of Offenbach's wittiest operettas, and of Bizet's *Carmen* which first introduced to the operatic stage the kind of working-class girls that fascinated Degas, achieved an enormous popular success in France between 1870 and 1880 with his stories about the Cardinal family. In *Ces Demoiselles de l'Opéra*, the *Vieil Abonné* acknowledges the truthfulness of Halévy's portrayal of the unscrupulous mothers' jealously guarding their daughters' virginities only to auction them off in due course to the highest bidder.

As well as the "high" art forms of opera and ballet (however debased), Degas greatly enjoyed the popular art form of the Café Concert, which reached its peak in the 1870s. In works toward the end of that decade such as *Aux Ambassadeurs* [34, 35] and *The Song of the Dog* [36] (both executed in pastel on top of a monotype print) Degas vividly captures the animated gas-lit atmosphere of the Café Concerts, with the gaudily dressed prostitutes weaving their way through the crowds in search of customers. According to *The Pretty Women of Paris*, not only did prostitutes find the floors of the Café Concerts

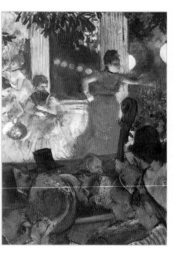

rich hunting-grounds but many took to the stage in order to increase their connection and display their charms. Perrine, for example, "graces the music-hall stage with her presence, but only for the purposes of prostitution, for she has but a piping, shrill little voice."

The Song of the Dog [36] shows the most famous Café Concert star of the time, Thérésa. Degas enthused about her. "She opens her mouth and out comes the largest and yet the most delicate, the most wittily tender voice there is." Earning a reputed 30,000 francs a year and the owner of a magnificent house at Asnières, Thérésa had no financial need for prostitution but, in the words of *The Pretty Women of Paris*, "Thérésa is occasionally sought after by rich strangers, who spend a few hours with her out of curiosity." We are

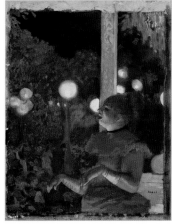

also informed that "the curse of her life has been her voracious appetite for active tribadism" and that "If the rakes who seek the enjoyment of her body bring a fresh-looking girl with them as a sacrifice to the insatiable Sappho, they will not be asked for a fee..."

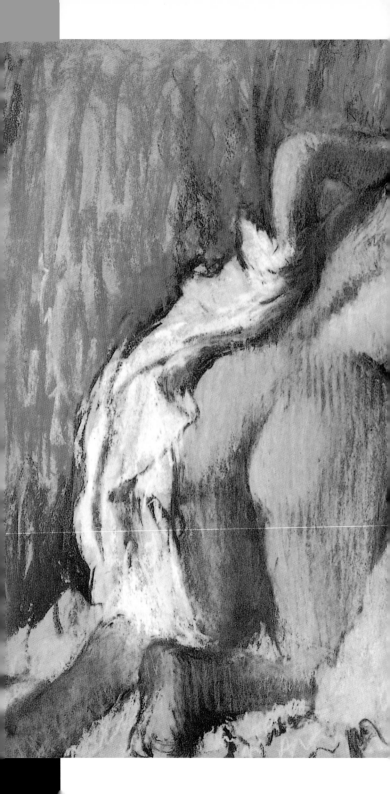

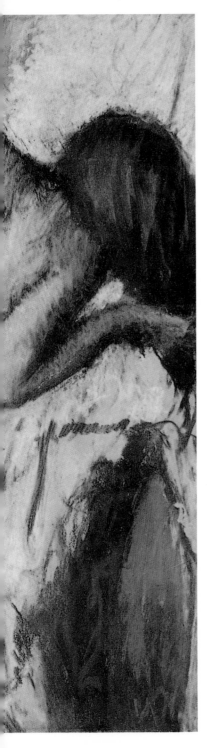

In the 1880s Degas began the splendid series of *Toilettes* [39-49] - women washing and drying themselves and combing their hair - which constitute one of his greatest achievements. These *Toilettes* mark a significant break with the post-Renaissance tradition of depicting the female nude as a glorified pin-up self-consciously displaying her charms for the benefit of the male viewer. As Degas explained to the Irish writer George Moore, "Until now the nude has always been represented in poses which presuppose an audience, but these women of mine are honest, simple folk, involved solely and entirely in what they are doing. Here is an individual person; she is washing her feet. It is as if you were looking through a keyhole."

39. Woman Drying Herself, ca. 1894
 Pastel on paper. 65 × 63 cm
 National Gallery of Scotland,
 Edinburgh

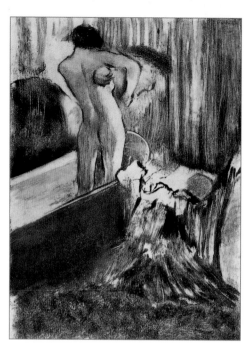

40. The Bath, ca. 1880. Monotype. 21.3 × 16.4 cm
 Statens Museum for Kunst, Den Kongelige
 Kobberstik, Samling Kobenhavn

In none of these *Toilettes* does Degas
individualise the facial features of his
models. Faces are either hidden or
blurred and indecipherable. Degas'
subject is "woman" rather than partic-
ular women. He observes her behav-
iour with the pseudo-objectivity of a
scientist studying a primitive tribe or
another species. Such an attitude
seems disconcerting in today's moral
and political climate. Degas himself
remarked "I have perhaps too often
perceived woman as an animal."

41. After the Bath, 1890-93 (dated 1885 by a later
 hand). Pastel on tracing paper: 66 × 52.7 cm
 The Norton Simon Museum of Art, Pasadena

Following spread:
42. The Tub, 1885/86. Pastel on paper: 70 × 70 cm
 Hill-Stead Museum Farmington, Connecticut

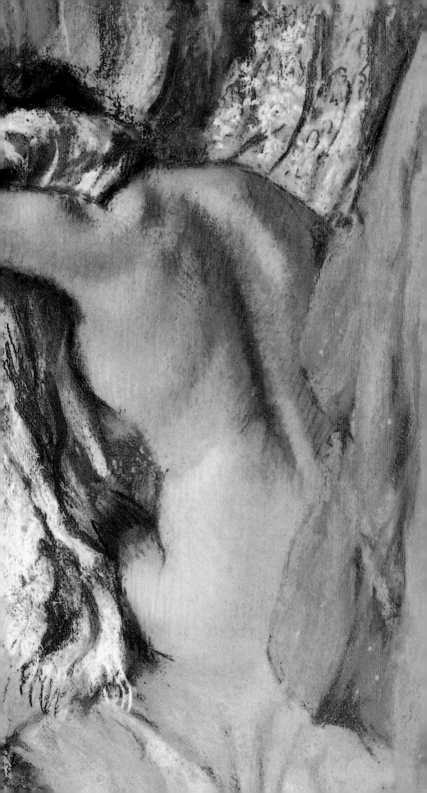

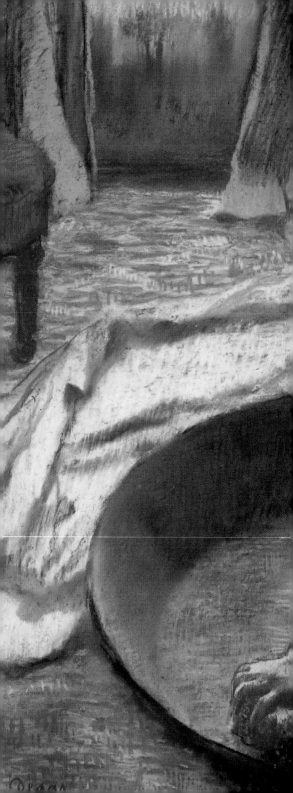

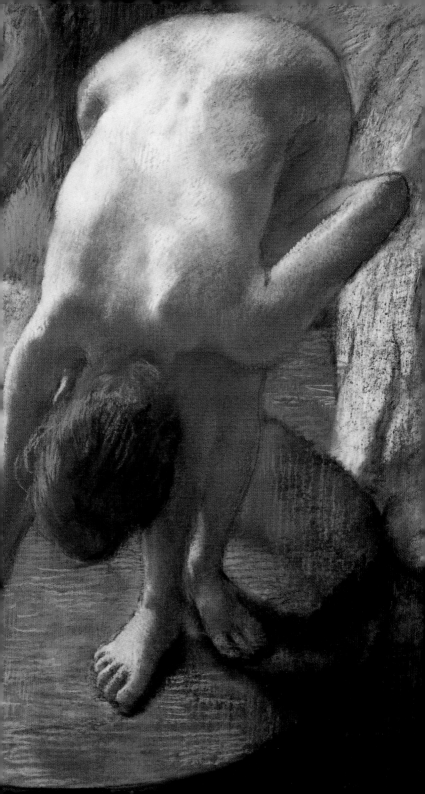

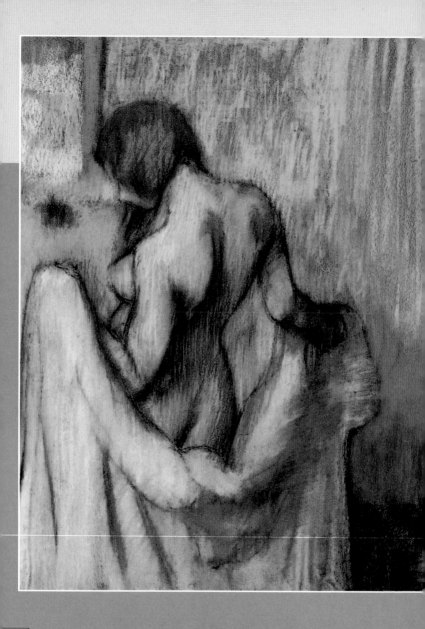

43. Woman with a towel, 1898
 Pastel on paper. 95.4 × 75.5 cm
 The Metropolitan Museum of Art, New York.
 H. O. Havemeyer Collection.

Another reason for Degas' avoidance of his models' faces may have been his disgust for the slick and salacious female nudes on show at the Paris Salons. The obscenity of those pictures lay not so much in the nudity as in the coyly enticing facial expressions.

There were those who regarded Degas' Toilettes as an attack on womanhood and a denial of sensuality. Even Joris Karl Huysmans who greatly admired Degas' work took this view, claiming that Degas had "in the face of his own century flung the grossest insult by overthrowing woman, the idol who has always been so gently treated, whom he degrades by showing her naked in the bathtub and in the humiliating dispositions of her private toilet" [42, 46, 47]. For Huysmans Degas had gloried in "his disdain for the flesh as no artist has ventured to do since the Middle Ages..."

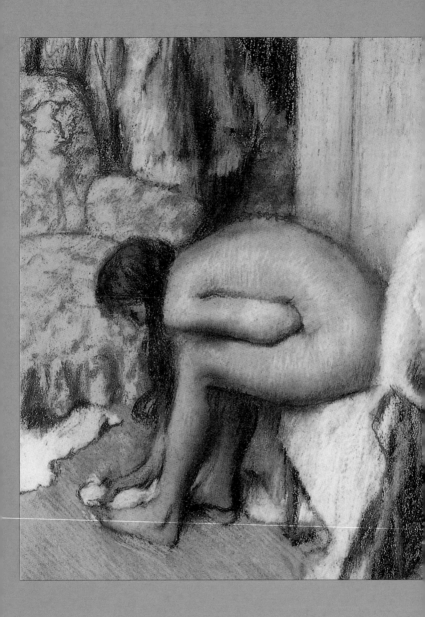

44. Naked Woman Drying her Foot, 1885/86
Pastel on paper. 54.3 × 52,4 cm
Musée d'Orsay, Paris

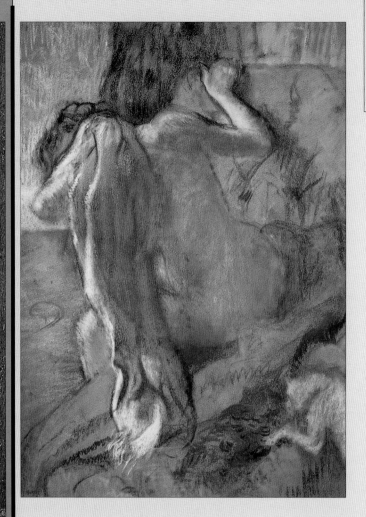

45. Woman Washing Herself, ca. 1894
 Pastel. 83 × 62 cm
 Galerie Beyeler, Basel

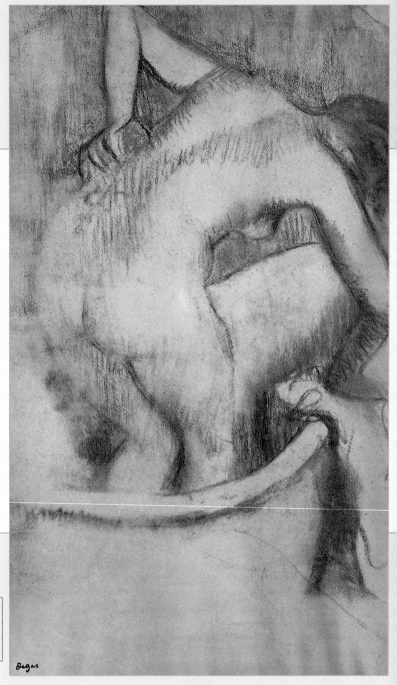

98

Degas

Far from disdaining flesh, many of these Toilettes express a powerful if sublimated eroticism. Both colour and line become increasingly charged with sensuality as the series progresses.

The rituals of washing can themselves be erotically charged, as we see from *The Pretty Women of Paris*, in which the personal hygiene of the women is described in enthusiastic detail. Clara Dermigny would offer her customers erotic books to read "while she is getting ready for them by performing the preliminary ablutions", and Elina Denizane was nicknamed Fleur-de-Bidet "because she is always astride that useful article of furniture, which plays such an important part in the toilette of a Frenchwoman".

46. The Bath: Woman Washing herself, ca.1887
 Crayon et pastel. 58 x 35.5 cm. Private collection

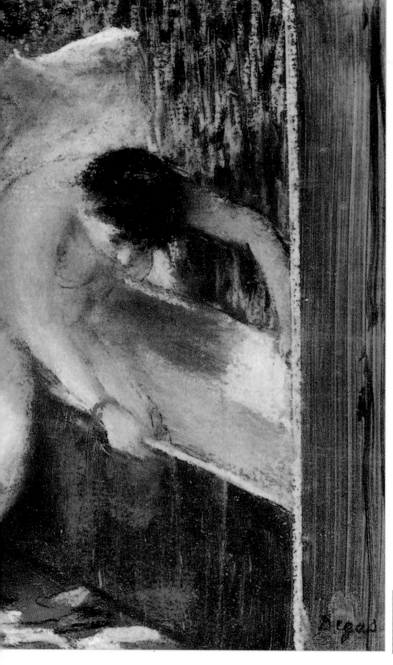

47. Woman Leaving Her Bath, ca. 1877
 Pastel over monotype. 16 x 21.5 cm. Musée d'Orsay, Paris

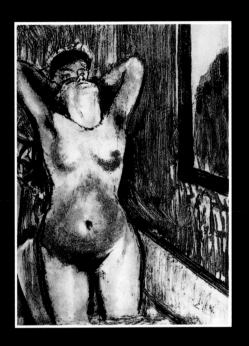

48. The Tub, ca. 1880
Monotype.

It is no coincidence that the theme of the Toilette was first touched upon in the series of monotype prints devoted to the brothel in the late 1870s. In *Admiration*, the voyeurism is made comically explicit by the appearance of a portly middle-aged man who seems to crawl up from underneath the bathtub. In another print from the series, a dark-suited gentleman quietly watches a nude woman combing her hair.

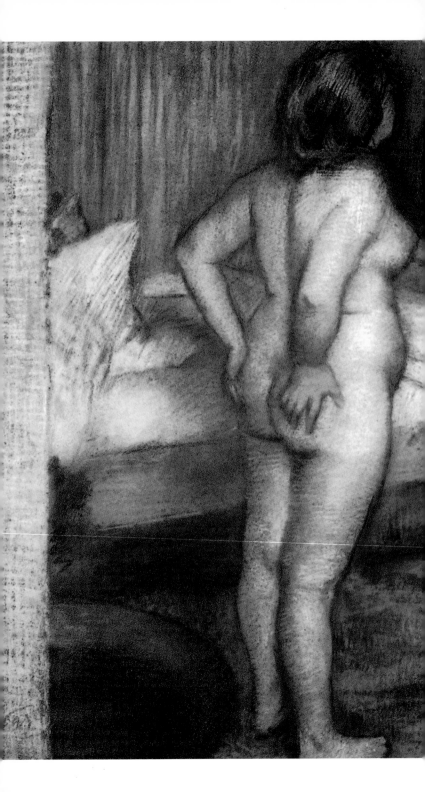

There is an oblique hint of "preliminary ablutions" in works such as *The Morning Bath* [50,56] in the Institute of Art in Chicago, or *The Bath* in the Carnegie Museum of Art in Pittsburgh, in which a bed is placed prominently in the foreground. In both cases the viewer would seem to be watching from the bed itself, although the ablutions could perhaps be more accurately described as post-coital rather than preliminary, for the beds are already rumpled.

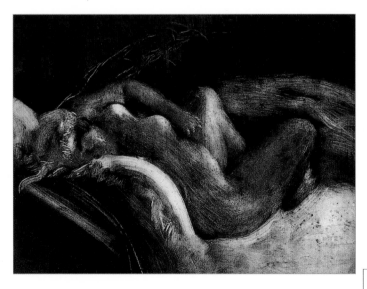

49. Nude woman Scratching Herself, 1879-83
 Monotype. 27.6 x 37.8 cm. British Museum, London

50. The Morning Bath (The Baker's Wife), 1885-86
 Pastel on paper. 67 x 52 cm
 The Henry and Rose Pearlman Foundation

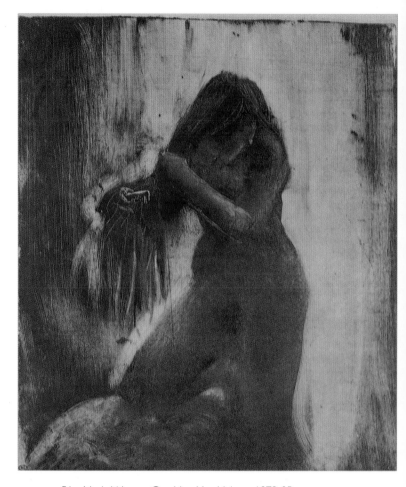

51. Nude Woman Combing Her Hair, ca. 1879-85
Monotype. 31.3 × 27.9 cm
Musée du Louvre, Paris

Amongst the most voluptuous of Degas' nudes
are those combing their hair. Degas was fasci-
nated by women's hair. There are stories of him
happily combing the hair of his models for
hours on end. In one of the odder episodes of
his career he alarmed the family of his friend
Ludovic Halévy by writing a formal letter to
request permission to see Geneviève Halévy
(widow of the composer Georges Bizet) with
her hair down.

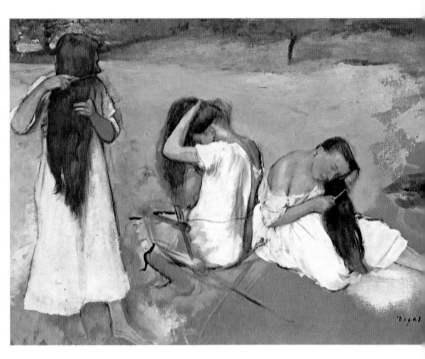

52. Women Combing Their Hair, ca. 1875-76
Oil on canvas. 34.5 x 47 cm
Phillips Collection, Washington

Such hair fetishism was common to many late nineteenth-century artists and writers. The novelist Mrs Gaskell remarked on Dante Gabriel Rossetti's fascination with women's hair [51-53], and described how when a woman with beautiful hair entered the room he was "like the cat turned into a lady, who jumped out of bed and ran after a mouse". Among the many other artists of the period who had some sort of fixation on women's hair were Münch, Mucha and Toorop.

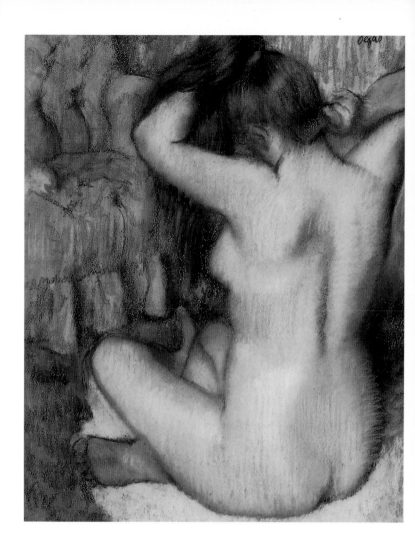

The literature of the late nineteenth century also abounds in erotic images of women's hair. Pierre Louÿs' poem *Hair* (which inspired an exquisite song by Debussy) expresses the claustrophobic sensuality of being enveloped in a woman's hair. Most famous of all is the scene in Maurice Maeterlinck's play *Pelléas et Mélisande* in which Mélisande leans out of her bedroom and allows her abundant hair to fall over Pelléas standing beneath.

53. Nude Woman Combing Her Hair, ca. 1886-88
 Pastel on paper. 78.7 x 66 cm
 Collection Mr and Mrs A. Alfred Taubman

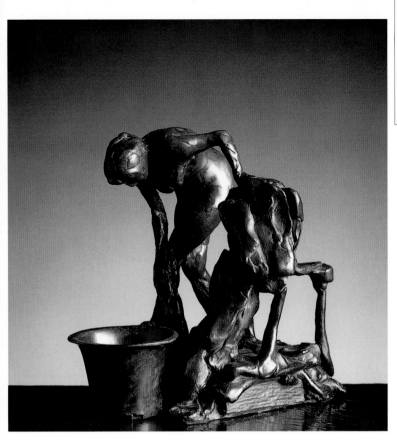

54. Woman Washing Her Left Leg, ca. 1900-03
 Bronze, H. 20 cm

If Degas' art is permeated from beginning to end
with overtones of prostitution, it remains neverthe-
less quite untainted by any element of sleaziness. In
his famous series of essays inspired by the Salon of
1846, Baudelaire speculated on why it is that repre-
sentations of erotic subjects are so often depressing
and disappointing. The defect of most, he thought,
was "a lack of sincerity and a naïveté".

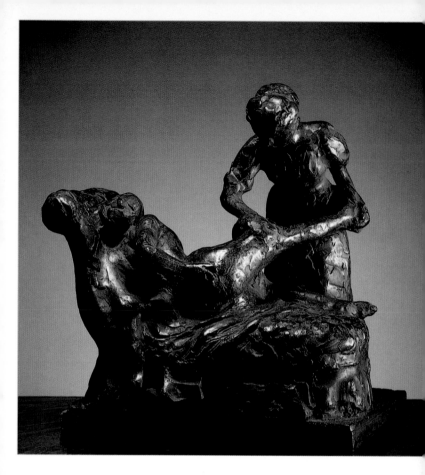

55. The Masseuse (group), ca. 1900-03, Bronze, H. 43 cm

But he believed it was possible to make great art out of such subject matter. "All things are sanctified by genius, and if these themes were treated with the necessary care and reflection, they would in no wise be soiled by that revolting obscenity which is bravado rather than truth." It is precisely his "naïve" truthfulness and the element of reflection that enable Degas to transmute base metal into purest gold. As Renoir remarked to the dealer Vollard apropos the monotype print of *Madame's Name-Day*, "At first sight such a subject may often seem pornographic. Only someone like Degas could endow *Madame's Name-Day* with an air of joyousness and with the grandeur of an Egyptian bas-relief."

56. The Morning Bath, ca. 1895
Pastel on paper. 70 × 43 cm, Art Institue, Chicago

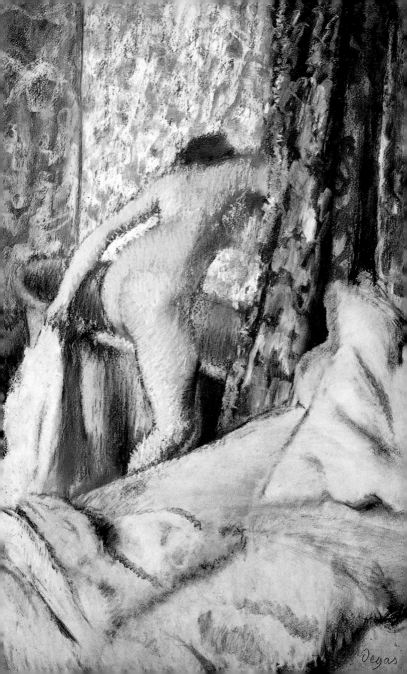

BIBLIOGRAPHY

Lillian Schacherl, *Edgar Degas, Dancers and Nudes,* Munich, Prestel, 1997.

Degas, catalogue of exhibition, Fondation Pierre Gianadda, Martigny, 1993.

Bernd Growe, *Edgar Degas*, Germany, 1994.

ILLUSTRATIONS